CANADIAN ART OF THE FIRST WORLD WAR

WITNESS

*Amber Lloydlangston
and Laura Brandon*

W9-AHM-204

CANADIAN
WAR MUSEUM
MUSÉE CANADIEN
DE LA GUERRE

Library and Archives Canada
Cataloguing in Publication

Lloydlangston, Amber
Witness – Canadian art of the First World War /
Amber Lloydlangston and Laura Brandon.

(Souvenir catalogue series)
Issued also in French under title: Témoin – art
canadien de la Première Guerre mondiale.
Exhibition catalogue.
ISBN 978-0-660-20282-2
Cat. no.: NM23-5/6-2014E

1. World War, 1914-1918 – Art and the war –
 Exhibitions.
2. World War, 1914-1918 – Canada – Exhibitions.
3. Art, Canadian – 20th century – Exhibitions.
4. War in art – Exhibitions.
5. Canadian War Museum – Exhibitions.
I. Brandon, Laura
II. Canadian War Museum
III. Title.
IV. Title: Canadian art of the First World War.
V. Series: Souvenir catalogue series.

N8260 L56 2014
758'.93550207471384
C2014-980009-6

Published by the
Canadian War Museum
1 Vimy Place
Ottawa, ON K1A 0M8
www.warmuseum.ca

Printed and bound in Canada.

Cover illustration:
kaboom.ca

Souvenir Catalogue series, 6
ISSN 2291-6385

TABLE OF CONTENTS

TD BANK GROUP

TD Bank Group has long enjoyed a special relationship with the Canadian War Museum and we are proud to be the National Presenting Sponsor of **Witness – Canadian Art of the First World War** at the Museum and throughout its national tour.

The First World War was a pivotal event in Canada's history – it shaped us as a nation. During this time of change, the Bank of Toronto and the Dominion Bank were two of Canada's financial institutions that played an important role in financing war expenditures and supporting the innovation of war bonds, while many of the bank's employees served in the war in some capacity.

At the end of the war, banks were able to welcome back many employees who had served overseas, but also mourned the loss of those who had made the ultimate sacrifice. With its support of this exhibition, TD is honoured to commemorate all of its employees and all Canadians who have served in the armed forces.

TD's sponsorship of this very special
exhibition is an important example of a
commitment to making Canada's rich history
even more accessible to Canadians. It is our
hope that exhibitions such as **Witness**, with
its unique and often intimate viewpoints,
can help to bring historical events to life. We
are pleased to partner with the Canadian
War Museum in bringing significant
historical pieces, many of which have never
been presented in public, to all Canadians.
We hope to help stimulate a nation-wide
conversation about the First World War.

FOREWORD

The Canadian War Museum holds one of the world's foremost collections of war art. It comprises more than 13,000 paintings, drawings and sculptures dating from the 18th century up to the present day. Among these works are some 2,500 pieces produced during, and immediately after, the First World War (1914–1918).

War art came not only from artists but also from ordinary soldiers. As art students and architects, ministers and grocers prewar, soldiers had notably varied backgrounds. In wartime, they found the time and the tools to depict their experiences as a means of sharing them with their comrades, families and friends. Their works continue to provide a unique and personal view of all they encountered as soldiers.

Professional artists, officially commissioned by the Canadian War Memorials Fund, also produced art during the First World War. The Fund was established in 1916 by Canada's Sir Max Aitken, later Lord Beaverbrook, as an offshoot of his Canadian War Records Office. It employed over 100 artists, the majority from Great Britain and Canada. They produced nearly 1,000 works commemorating Canada's remarkable contribution to the Great War. Their canvases gave those at home a glimpse of battlefield victories and tragedies, an appreciation of the soldiers' courage, spirit and humanity, and an idea of what motivated Canadians to fight and die for their country.

The artworks in the exhibition **Witness – Canadian Art of the First World War** and this publication allow us once again to almost see, sense, and hear the voices of those long-ago soldiers. One hundred years later, we are given the opportunity to stand in witness to their lived experiences.

James Whitham
Director General,
Canadian War Museum,
and Vice-President,
Canadian Museum of History

INTRODUCTION

One hundred years ago, the art of Canadian painters and soldiers helped bring the First World War home to Canada. Today, these same works continue to help us understand and appreciate Canada's role in the unprecedented global conflict that was the First World War.

During the conflict, artists grappled with how to depict the unfamiliar sights that confronted them, such as tanks and gas attacks, dead and wounded soldiers, shelled buildings and towns, and women at work in factories. Some artists fit these new experiences within a familiar artistic framework. Others recognized and embraced the novelty of their situation, finding new ways to depict the war as they saw it so that other people might comprehend what they had witnessed.

This souvenir catalogue is a companion to **Witness – Canadian Art of the First World War**, an exhibition that presents a selection of this artwork. It showcases officially commissioned, massive canvases and tiny, personal sketches. All the works in the exhibition tell a story about the First World War and the individuals who lived through it.

Created by the Canadian War Museum as a travelling exhibition, **Witness** will feature, at each venue, a different selection of war

art from among more than 100 works by 61 artists. These artists include celebrated Canadians such as A. Y. Jackson, Frederick Varley, Arthur Lismer and Frank Johnston, who later became members of the Group of Seven. Well-known British artists Alfred Munnings and R. Caton Woodville are also represented. Equally poignant and powerful are the works produced by ordinary Canadian soldiers, some of whom had been artists and architects in their prewar civilian lives. Men like Douglas Culham, Vivian Cummings, George Sharp and Frederick Clemesha used art to record their experiences and left behind a powerful record of the war and its impact on individuals and the environment.

As Canada's national museum of military history, the Canadian War Museum has an important role to play in marking the centenary of the First World War. The Museum's exceptional collection of war art offers Canadians a unique means of imagining and reimagining this conflict, and remembering the individuals who fought in it. Both **Witness** and this companion publication encourage Canadians to reflect on the personal and national reach of this epic event.

CANADIANS AT WAR

Among the many subjects that confronted professional and amateur artists were soldiers overseas and civilians on the home front.

Both official war artists and soldier-artists portrayed Canadian military personnel as brave combatants and as wounded survivors. Notably absent, however, are images that show Canadian soldiers as victims of shell-shock or overwhelming fear.

On the home front, official war artists depicted men and women labouring to produce the ammunition and equipment required by the fighting forces. Munitions factories were one of the few First World War subjects that female artists painted and in which women are featured.

Sergeant T. W. Holmes, V.C.

In this painting, fresh-faced Victoria Cross recipient Sergeant Tommy Holmes, his soft cap at an angle, appears younger than his 20 years.

Artist Ernest Fosbery painted this portrait around 1918. Before this, he had been an officer with the Canadian Expeditionary Force. In 1917, while recovering from wounds suffered at the Somme in France, Fosbery learned of the Canadian war art program.

To his dismay, he discovered that it had not engaged Canadian artists. Fosbery wrote to the Canadian War Memorials Fund: "Canada is taking its place as a nation and Canadian art has more than kept pace with the developments of the country. Would it not be possible to have this essentially Canadian series of portraits be done by Canadian artists?" The Fund agreed and Fosbery became one of the first official Canadian war artists.

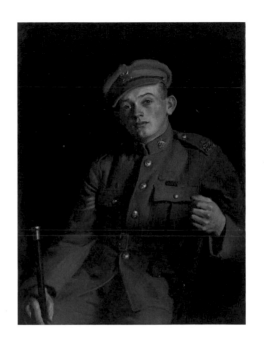

Ernest Fosbery (1874–1960)
Sergeant T. W. Holmes, V.C., around 1918
Oil on canvas
102 x 77 cm

The Birth of an Army, Valcartier, 1914

Here, landscape artist Homer Watson
commemorates the training of the First
Canadian Division at Valcartier Camp,
Quebec. Watson initially felt that this
new topic had little "artistic quality." After
grappling with it, he decided to subject
the soldiers and the tents "to the
landscape, for the army had its birth
in the hills of Valcartier."

Canada's Minister of Militia and Defence
Sam Hughes commissioned Watson to paint
the camp in 1914. Unfortunately, Hughes did
not obtain approval from Cabinet or discuss
a price with Watson. When Watson asked
to be paid for the three paintings he had
produced (including this one), no funds had
been allocated. The government agreed to
pay him $10,000: half of the $20,000 he had
requested. Watson was disappointed. He felt
that "some of the best work of [his] life [had]
gone into those camp pictures."

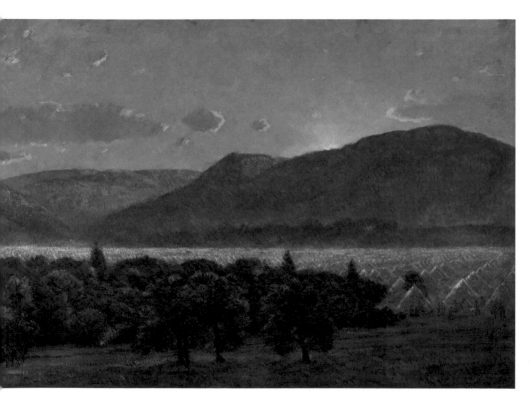

Homer Watson (1855–1936)
The Birth of an Army, Valcartier, 1914, 1915
Oil on canvas
154 x 306 cm

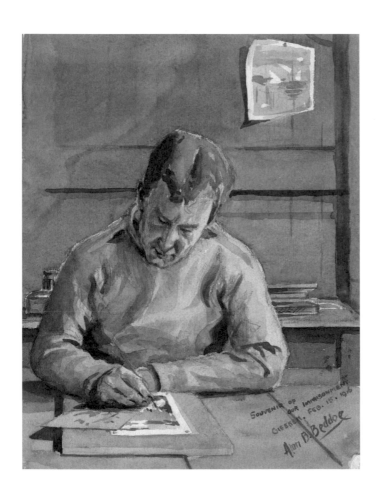

Souvenir of our imprisonment
Giessen. Feb. 15. 1916

Alan B. Beddoe

14

Private A. Nantel

Arthur Nantel and Alan Beddoe were both soldier-artists who became prisoners of war. Beddoe painted this watercolour portrait of Nantel as a souvenir of their incarceration at Giessen, Germany. It is dated February 15, 1916. Both men had been taken prisoner during the April 1915 Second Battle of Ypres and, at Giessen, both were encouraged to paint by their German captors.

After the war, Beddoe opened a commercial art studio in Ottawa, Ontario. Over the course of his career, he designed many coats of arms. He also supervised the illumination of the *Books of Remembrance*, which commemorate Canadians killed in the First and Second World Wars (1914–1918, 1939–1945) and the South African War (1899–1902), and now lie in the Peace Tower of the Parliament Buildings in Ottawa. In 1964, as Canadians debated the design of a new national flag, Beddoe worked with Prime Minister Lester B. Pearson on different concepts. One featured three maple leaves on a white background flanked by two blue borders. Although not selected, Beddoe's design was Pearson's favourite, earning it the nickname the "Pearson Pennant."

Alan Beddoe (1893–1975)
Private A. Nantel, 1916
Watercolour on paper
25.3 x 20

The Artist's Home at Bottom Wood

This self-portrait of Canadian soldier-artist Thurston Topham shows him sitting outside his dugout. Beside him is a sign that reads: "The Studio. Please Ring."

A technical illustrator before the war, Topham enlisted in the Canadian Expeditionary Force in 1916. In France with the 1st Canadian Siege Battery, he used his artistic talents to produce observation sketches for military intelligence at the Battle of the Somme. In his spare time, and when he could obtain the necessary materials, Topham produced watercolours like this one, which give a glimpse into the lives of ordinary soldiers. Gassed after two months at the front, Topham spent the remainder of the war battling health problems.

In November 1918, Canadian War Memorials Fund representatives saw examples of Topham's drawings published in the American *Scribner's Magazine* and decided that his "vigorous and interesting" sketches should be acquired. The Fund purchased 50 of his drawings in 1919 for $500.

Thurston Topham (1888–1966)
The Artist's Home at Bottom Wood, about Halfway between Mametz and Contalmaison, 1916
Watercolour and crayon on paper
24.7 x 33.8 cm

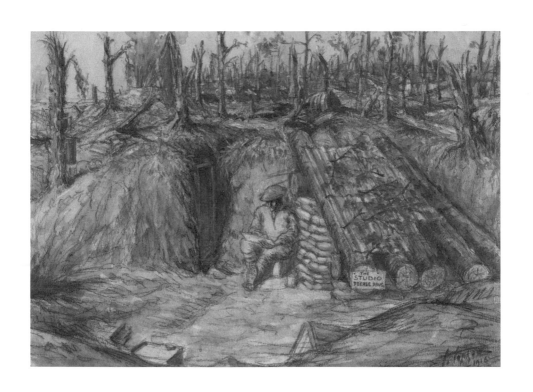

The Author at Work

An architect by training, Captain George Sharp drew this portrait of himself sitting on a crate marked "Bombs GS [General Service] Handle with Care."

Blithely unconcerned by the rambunctious rats around him, Sharp's whimsical drawing makes light of the war and provides an incomplete picture of his experiences. A scout officer, he received the Military Cross for his "great coolness and courage" in sending back "information that materially assisted his brigade" during an advance. He received a bar to this medal for succeeding in "getting forward to the most advanced posts and obtaining exact and most valuable information," all the while displaying "great courage and devotion to duty."

Sharp returned to architecture after the war. He designed Vancouver's Burrard Bridge, as well as buildings at the University of British Columbia, among other projects.

George Sharp (1880–1974)
The Author at Work, between 1915 and 1918
Graphite on paper
21 x 15.3 cm

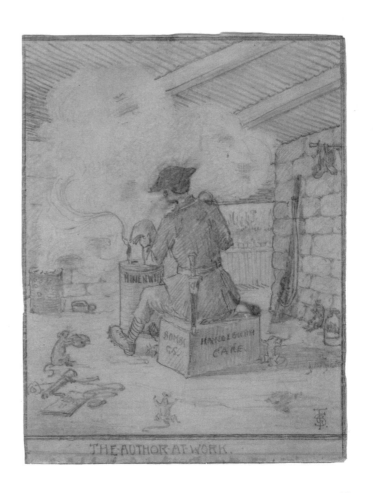

THE AUTHOR AT WORK.

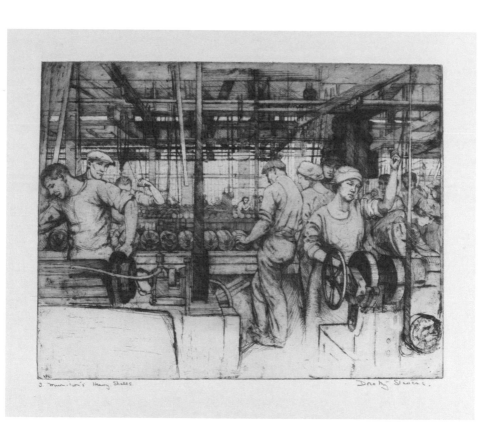

I. Munition's Heavy Shells. Dorothy Stevens.

20

Munitions — Heavy Shells

This print by Dorothy Stevens depicts women and men working in a shell factory. Asked to express "as far as possible the activity...and clothes of the workers," it's clear she kept her instructions in mind.

Stevens approached the Canadian War Memorials Fund and asked if she could contribute to the work of recording Canada's war effort on the home front. She had heard of the program through Frances Loring, a sculptor and friend already engaged in the scheme. When her offer was accepted, Stevens launched into her work, finding it "thrilling going over factories and shipbuilding yards." She ultimately produced a series of eight etchings of these subjects although the Fund had only enough money to purchase six.

Dorothy Stevens (1888–1966)
Munitions – Heavy Shells, around 1918
Etching on paper
39.6 x 48.6 cm

A Canadian Soldier, Marching

This sketch of a Canadian soldier marching is by Welsh artist Augustus John. The two sets of legs show us that he experimented with how to draw this part of the body. John also drew a second left hand to determine how to depict it.

Hired as an official war artist by Canada's Lord Beaverbrook, founder of the Canadian War Memorials Fund, John drew this sketch and many others in preparation for a large mural that was never completed. Called *The Canadians Opposite Lens*, it had been destined to be the centrepiece for a war memorial gallery in Ottawa, Ontario. But the gallery was never built and the unfinished mural remained in John's studio until his death. The Canadian War Museum acquired the 12 by 3.7 metre work in 2011.

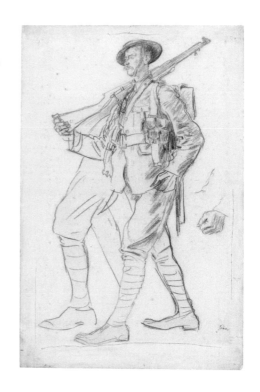

Augustus John (1878–1961)
A Canadian Solider, Marching, undated
Graphite on paper
51 x 33 cm

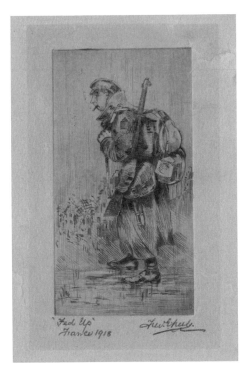

Frederick Neel (1872–?)
"Fed Up," France, 1918, 1918
Etching and ink wash on paper
25.6 x 20.3

"Fed Up," France, 1918

This print by Lieutenant Frederick Neel depicts a tired soldier with full kit on his back, a rifle slung over his shoulder and a cigarette in his mouth.

A veteran of the South African War (1899–1902), when he enlisted in the Canadian Expeditionary Force in September 1915, Neel gave his profession as "soldier." By 1918, the date of this print, Neel may have been expressing his own fatigue and disillusionment with war and army life. He had been wounded by a rifle grenade that exploded in his face in December 1916. It left him with a piece of shrapnel in his head that caused severe pain. The shrapnel was removed in 1917 but his health continued to be poor until his demobilization in 1920.

Canadian Soldier Lighting his Pipe

Official Canadian war artist Inglis Sheldon-Williams produced this drawing of a soldier lighting his pipe. It is a preparatory drawing for a large oil painting depicting the arrival of the Canadians on the Rhine to act as an occupying force after the war ended in November 1918.

Sheldon-Williams had a wealth of experience depicting military subjects. As an employee of the British weekly newspaper *The Sphere*, he had drawn scenes from the South African War (1899–1902) and the Russo-Japanese War (1904–1905). Before his commission as a Canadian War Memorials Fund artist in 1918, Sheldon-Williams had tried three times to enlist in the British Army and once to join the Canadian Expeditionary Force. In his 40s, he was considered too old.

Inglis Sheldon-Williams (1870–1940)
Canadian Soldier Lighting his Pipe *(Study for Canadians Arriving on the Rhine)*, 1919
Graphite and pastel on paper
31.6 x 24.2 cm

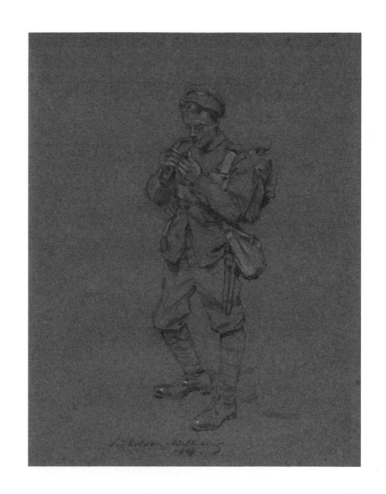

Tommy

Gunner Ross Wiggs painted this cheerful "Tommy," a nickname for British and Canadian soldiers.

This soldier has one yellow wound stripe on his sleeve and a red and blue shoulder patch, which marks him as a member of the 14th Battalion. Wiggs was studying in Montréal, Quebec, at McGill when he enlisted with the McGill University Siege Artillery Draft, a reinforcement unit for the university's 271st Canadian Siege Battery, in April 1917. He survived the war and became a successful architect and artist. His *Tommy* is one of a series of cartoons showing what Wiggs described in 1969 as the "more or less humourous side of life in the army during the First World War."

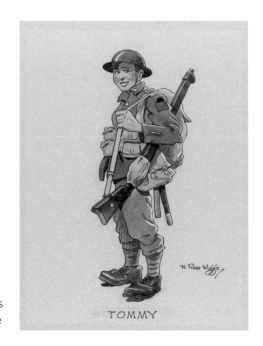

TOMMY

Ross Wiggs (1895–1986)
Tommy, undated
Watercolour on paper
62.9 x 47.9 cm

The Dumbells

This watercolour by Private Leonard Young depicts the artist (*right*) with Hubert Stubbs (*left*), dressed in women's clothing. Both were members of the famous First World War vaudeville troupe, the Dumbells.

An artist and pianist before the war, Young had enlisted with the 9th Field Ambulance in 1916. With his talents, Young soon found his way to the stage, where he helped boost troop morale. He was first recruited to play the piano for the Princess Patricia's Canadian Light Infantry Comedy Company, formed in 1916. He returned to the Field Ambulance in the fall of that year and lost his left leg in the fighting at Vimy Ridge, France, in June 1917. After he recovered from his injury, Young joined the Dumbells.

Leonard Young (1886–?)
The Dumbells, between 1917 and 1919
Carbon and watercolour on paper
34.2 x 25.6 cm

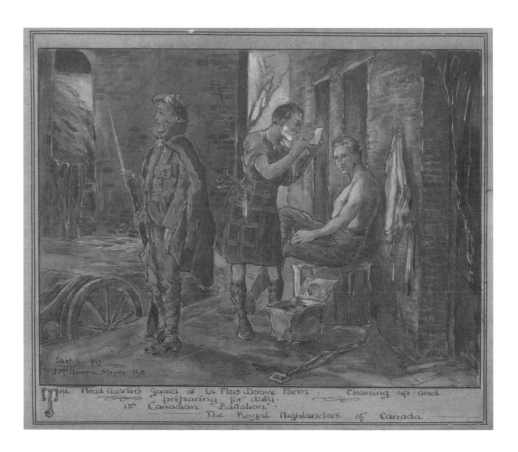

Sketch by
J. McQueen Mayes 1918

The Head Quarters guard at La Plus Douve Farm. Cleaning up and
preparing for duty.
13th Canadian Battalion.
The Royal Highlanders of Canada.

The Headquarters Guard at La Plus Douve Farm

Here, Private John McQueen Moyes depicts Canadian soldiers "cleaning up and preparing for duty" behind the lines at their battalion headquarters, La Plus Douve Farm, in Belgium.

Moyes enlisted with the 13th Canadian Battalion in September 1914. He remained uninjured during his 38 months in France. It was not until he went to England for officer training in 1918 that he required medical care: he caught bronchitis.

John McQueen Moyes (1888–1948)
The Headquarters Guard at La Plus Douve Farm Cleaning up and Preparing for Duty.
13th Canadian Battalion The Royal Highlanders of Canada, 1915
Ink and gouache on cardboard
21.3 x 25.4 cm

Stretcher-Bearers with an Ambulance

In this drawing by artist R. G. Mathews, stretcher-bearers carry what could be either a bundle of blankets or a wounded soldier toward an ambulance.

Before the war, Mathews had regularly published drawings of celebrities and current events in the Canadian magazine *Grip* and the *Montreal Star* newspaper. Living in England when the First World War broke out, Mathews became an Honourary Lieutenant in the Canadian Army Medical Corps in December 1915. He visited hospitals in England and France before being assigned to the Director, Medical Services, to work "in connection with historical records" in 1918. During the war, Mathews also produced a series of portraits for the magazine *Canada in Khaki* and scenes of Canadians in action for the British weekly newspaper *The Graphic*.

R. G. Mathews (1870–1955)
Stretcher-Bearers with an Ambulance, 1918
Crayon and watercolour on paper
19.8 x 24.7 cm

Vimy Ridge (The Pimple)
Valley of the Souchez River
opposite Hospital Corner
May. 17

Vimy Ridge from Souchez Valley

In this simple sketch made in May 1917, chaplain Captain Geoffrey d'Easum has drawn Hospital Corner, a sheltered spot near Vimy Ridge, in France. The "Pimple," the northernmost tip of the ridge, is visible in the distance.

Reverend d'Easum enlisted in May 1916 and soon met with the dangers and horrors of war. In October 1917, during the Battle of Passchendaele in Belgium, he was gassed. In October 1918, during the Battle of Cambrai in France, d'Easum was the only one of five men to survive a shell blast. Suffering from battle exhaustion, he wrote that the experience had left him "rather wobbly." In December 1918, d'Easum received the Military Cross for "conspicuous gallantry and devotion to duty." Like many chaplains at the front, he had "worked incessantly among the wounded and dying."

Geoffrey d'Easum (1871–1954)
Vimy Ridge from Souchez Valley, 1917
Ink and graphite on paper
17.9 x 25.4 cm

After an Advance

These allied soldiers may be Canadians.
Wearing arm bands with a red cross,
they search for wounded Germans
among the dead.

French Canadian soldier-artist Arthur Nantel,
captured during the April 1915 Second Battle
of Ypres, painted this work as a prisoner of
war in Giessen, Germany. He was encouraged
to paint by his captors, joining several other
artists in what they jokingly called the
"Giessen Studio." Nantel described painting
to try to "earn the value of a piece of sausage"
to satisfy his gnawing hunger. But painting for
food was better than what followed. Nantel
spent the last seven months of the
war slaving in a mine.

This watercolour was one of 30 that Nantel
carried out of Germany with him at war's end.
The works were exhibited in London, England,
in 1919 and later purchased by the Canadian
War Memorials Fund.

Arthur Nantel (1874–1948)
After an Advance, between 1915 and 1918
Watercolour on paper
23.5 x 33.8 cm

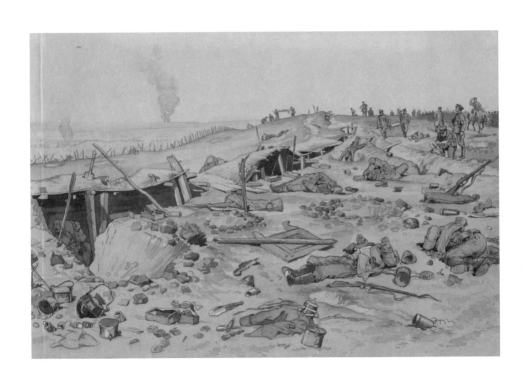

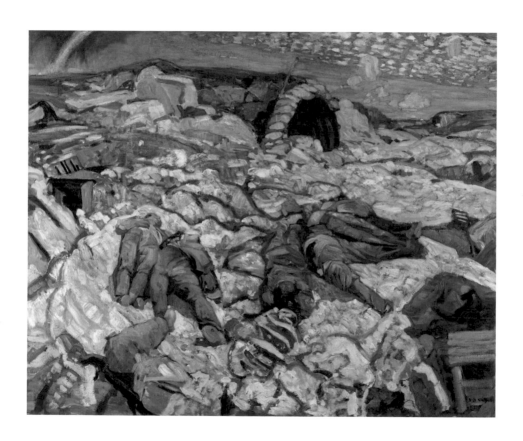

The Sunken Road

In this painting by future Group of Seven artist Frederick Varley, the dead are members of a German gun crew. Some critics view the distant rainbow as a sign of hope, while others see it as an ironic comment on the war.

Varley became an official war artist in 1918 and joined the Canadians in France in the fall of that year. A risk taker, he wrote to his wife Maud that he had placed himself in danger, but all with the intent of really seeing the war. Varley depicted his experiences through his art in the belief that people in Canada "must see...the dead on the field, freakishly mutilated" to begin to appreciate war's horrors. He mused that he had "mad subjects for painting. They won't help recruiting, but by Jove, they'll show what a diabolical game war is."

Frederick Varley (1881–1969)
The Sunken Road, 1919
Oil on canvas
132.7 x 162.7 cm

TOOLS OF WAR

Art provided public and private audiences with a unique view of this first mechanized war.

During the First World War, Allied and German forces manufactured and employed a vast array of equipment. Some technologies, like aircraft and tanks, were new. Others, like artillery and machine guns, were altered to increase their lethality. Paradoxically, both forces also required traditional equipment, such as horses and other pack animals, because mud, craters and other obstacles defeated the mechanized vehicles.

Officially commissioned artists and soldier-artists saw this equipment in production on the home front, in action overseas, or in ruins, its remains littering battlefields. They struggled with how to depict it. Sometimes, accuracy was the priority. At other times, they chose to interpret what was before them to communicate a particular message about the war and those waging it.

Starting the Freighter

This painting of shipbuilding at the Canadian Vickers shipyard in Montréal, Quebec, is by artist Albert Robinson.

For most of the war, Robinson was employed as a munitions inspector. In 1918, A. Y. Jackson, his friend and a future Group of Seven artist, recommended him to the Canadian War Memorials Fund: "Robinson would certainly understand his subject and is artist enough to achieve something quite above the average." At first Robinson ran into significant obstacles. Exasperated, he wrote to the Fund that he could not "get into those works to save my boots." Finally allowed on site, Robinson produced paintings that justified Jackson's confidence in him.

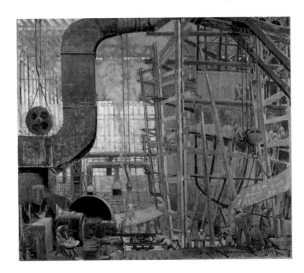

Albert Robinson (1881–1956)
Starting the Freighter, 1919
Oil on canvas
182 x 203.5 cm

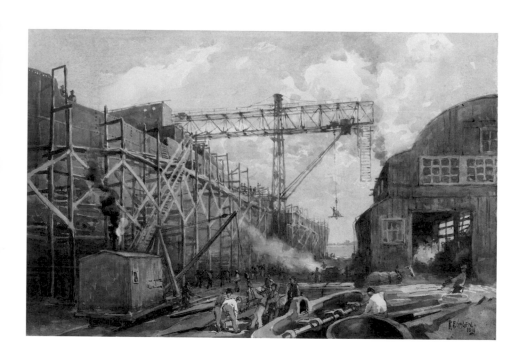

Polson Iron Work Yard, Ship **War Hydra** *on Stocks*

Construction of the freighter *War Hydra* is shown in this watercolour.

In September 1918, the Canadian War Memorials Fund suggested to artist Robert Gagen that he seek out "material for a good war records picture" in the shipbuilding underway in Toronto, Ontario. Gagen agreed and produced several works that record this important activity.

The freighter *War Hydra* and others like it built at Polson and in other Canadian shipyards replaced those lost to German U-boat attacks. But after the war ended in November 1918, Polson was unable to secure further contracts. In March 1919, it filed for bankruptcy. Today, the shipyard site is buried beneath the Toronto railway viaduct.

Robert Gagen (1847–1926)
Polson Iron Work Yard, Ship* War Hydra *on Stocks, 1918
Watercolour on art board
33.7 x 51.1 cm

Olympic *with Returned Soldiers*

This painting by future Group of Seven artist Arthur Lismer depicts the arrival of the *Olympic* in Halifax Harbour, Nova Scotia, on December 14, 1918. On this trip, the *Olympic*, a sister ship of the *Titanic*, carried more than 5,300 returning soldiers, a fraction of the 200,000 it transported between 1914 and 1919.

The light had been poor on that December day but Lismer recorded the conditions exactly. In March 1919, he wrote: "There are... thousands of people who will remember that day and the painting has to be absolutely correct as to wind, weather, and tide." Lismer also captured the ship's vivid "dazzle" camouflage, a paint scheme used to help protect ships from submarine attack.

Arthur Lismer (1885–1969)
Olympic *with Returned Soldiers*, 1919
Oil on canvas
123.0 x 163.3 cm

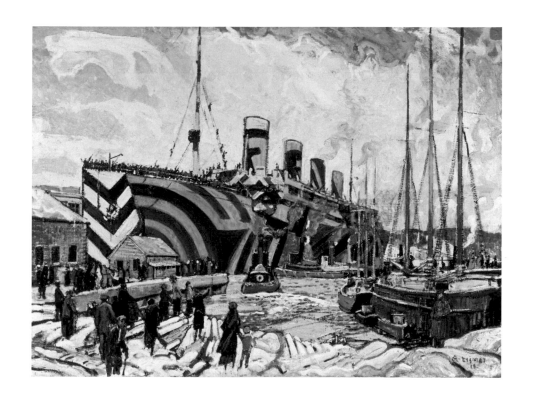

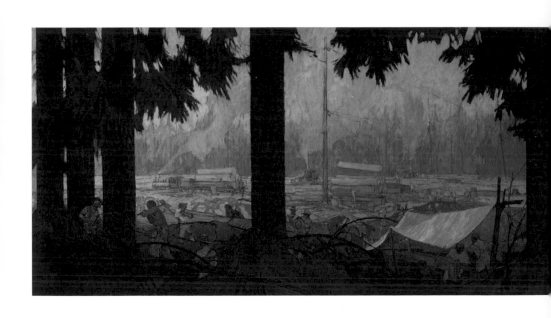

Charles Simpson (1878–1942)
Lumbering Aeroplane Spruce in B.C., 1919
Oil on canvas
122.1 x 367.5 cm

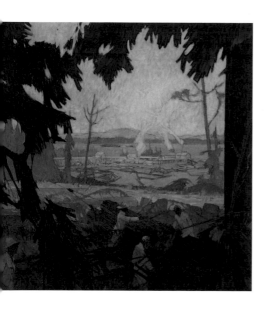

Lumbering Aeroplane Spruce in B.C.

Charles Simpson's painting portrays lumbering for aircraft production in British Columbia. This massive and impressive painting was last exhibited in Toronto, Ontario, in 1926.

An artist with the Canadian War Memorials Fund, Simpson first painted in England. Next, the Fund asked him to travel to Siberia to paint the war there. Simpson was willing but dwindling resources forced the Fund to choose a subject closer to home: spruce lumbering operations in British Columbia. By the time this new assignment had been confirmed, however, not only had the lumbering activities ceased, but the war itself had ended. Simpson worked instead from photographs provided by the director of the Imperial Munitions Board and notes taken during a visit to the province.

Hun Plane Caught in the Searchlights

Private David Carlile's watercolour depicts a German aircraft caught in Allied searchlights at the Arras-Cambrai Road, France, in September 1918. Shells explode around the plane, as Allied forces try to bring it down.

An architect before the war, Carlile enlisted in the Canadian Expeditionary Force in April 1915. In this watercolour, he captures the fierce fighting that typified the last months of the war. Artillery pieces fire and their shells explode in the distance. A tank lumbers across the battlefield in the far left foreground; nearby, an anti-aircraft gun takes aim at the hapless German plane. On the road, trucks drive into the distance and horses pull a wagon, while soldiers march and mounted troops ride to and from battle.

David Carlile (1885–?)
Hun Plane Caught in the Searchlights – Arras-Cambrai Road – France – Sept. 1918, 1918
Watercolour on paper
21.6 x 29.8 cm

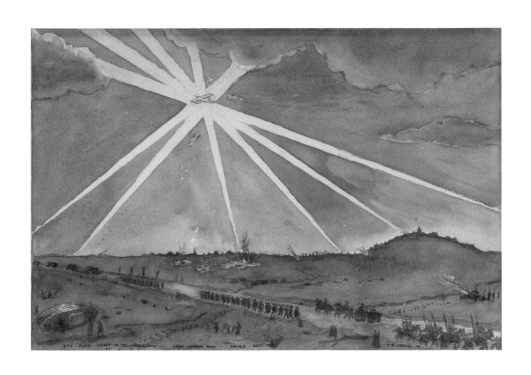

HUN 'PLANE CAUGHT IN THE SEARCHLIGHTS · ARRAS-CAMBRAI ROAD · FRANCE · SEPT 1918 · D.M. CARLILE ·

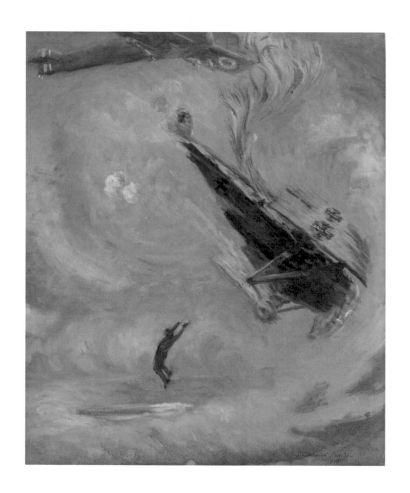

The Fall

The German pilot in this painting leaps from his burning aircraft to avoid death by fire. But we know that he will not survive the fall, since pilots were not issued parachutes. Above, the British winner of this dogfight continues on.

The artist, S. Chatwood Burton, was a professor of fine art and architecture at the University of Minnesota when he enlisted in the Canadian Expeditionary Force in August 1918. How he came to paint this work is not known. Indeed, more is known of its owner, Lieutenant, later Air Vice Marshal, Clifford McEwen. A Canadian First World War fighter ace, McEwen is credited with shooting down more than 20 enemy aircraft.

S. Chatwood Burton (1881–1947)
The Fall, 1918
Oil on canvas
48.2 x 40 cm

British Tank in Action

While in hospital in London, England, in December 1917, English landscape artist Daniel Sherrin painted this British tank in action.

Sherrin had fought in the September 1916 Battle of Flers-Courcelette, France, where tanks were used for the first time. His tank is not to scale and is almost animal-like in its ferocity, emphasizing the power of this new, terrifying weapon.

At Flers-Courcelette, some tanks succeeded in supporting the infantry. Canadian Private Donald Fraser of the 31st Battalion recorded in his journal that when their assault failed, they were "at the mercy of the enemy." But then tank C.5 ("Crème de Menthe") arrived and began firing on enemy positions, giving "new life and vigour to our men." During the battle, more tanks broke down or became stuck than functioned as intended.

Daniel Sherrin (1869–1940)
British Tank in Action, 1917
Oil on canvas
61.5 x 92 cm

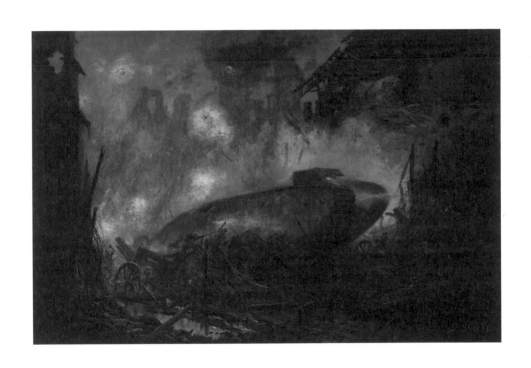

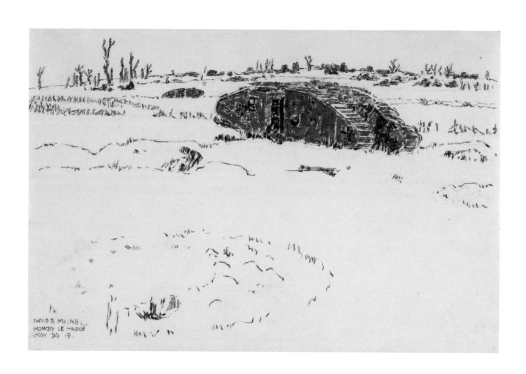

52

Wrecked Tanks

Canadian artist David Milne painted these destroyed tanks near Arras, France, in 1919.

Milne enlisted in the Canadian Expeditionary Force in March 1918 and became an official war artist in February 1919. Sent to France and Belgium in the summer of 1919 to paint the sites of Canadian battles, Milne wrote: "I saw and painted battlefields and trenches, tanks and wreckage and wire and obliterated villages, still just as the war had left them. I never could quite decide if I was the last soldier or the first tourist, but it was quite thrilling."

But he was also deeply moved by what he saw. After witnessing a soldier's reburial in an Imperial (now Commonwealth) War Graves cemetery in Courcelette, France, Milne wrote: "Here they lie, the men for whom life ended on the day of Courcelette, who never heard of Vimy or Passchendaele...No boat for Canada was to await them. The war, their war, ended at Courcelette."

David Milne (1882–1953)
Wrecked Tanks outside Monchy-le-Preux, 24 May 1919, 1919
Watercolour and graphite on paper
35.4 x 50.7 cm
National Gallery of Canada, Ottawa, Ontario
Transfer from the Canadian War Memorials, 1921
8438

Corner of Petawawa Camp

This watercolour by historical illustrator and official Canadian war artist C. W. Jefferys depicts an 18-pounder gun at Camp Petawawa, a training and artillery-testing site in eastern Ontario. It is hitched and ready for the team of six horses needed to transport it. At the bottom of the work, we can see how Jefferys experimented with his colours before using them.

Jefferys began work for the Canadian War Memorials Fund in 1918. Asked what he could contribute, he replied that painting" the work of the training camps" at home was something he "could do better than anything else." Jefferys subsequently painted camps in Toronto and Niagara, as well as Petawawa. While working, he would have seen many men training with the 18-pounder gun. It was the standard field gun of the First World War.

C. W. Jefferys (1869–1951)
Corner of Petawawa Camp, 1918
Watercolour on art board
26.7 x 38.6 cm

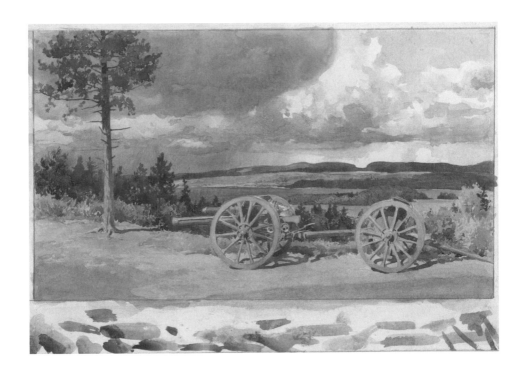

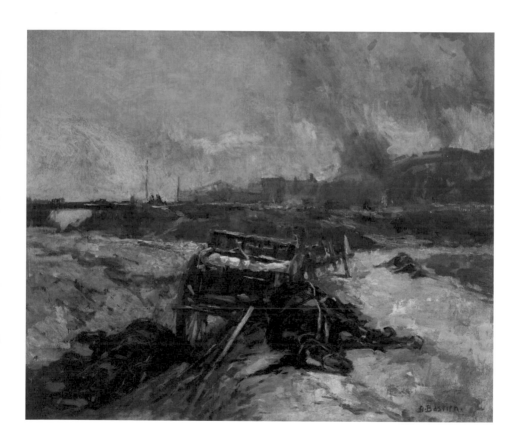

Artillery Horse Killed

In this painting by Belgian artist Alfred Bastien, two dead horses remain harnessed to the gun carriage they had been pulling.

Bastien depicted two tools that were indispensable during the First World War: artillery and horses. Artillery was the decisive weapon of the war, but it relied on horses to be effective. These animals hauled the guns and transported the shells that artillery needed to operate. In doing so, horses were exposed to the same dangers as soldiers. Although the Canadian Army Veterinary Corps strived to maintain the health of tens of thousands of army horses, thousands died. For soldiers, one of the most disturbing sounds they heard on the battlefield was the screaming of injured horses.

Alfred Bastien (1873–1955)
Artillery Horse Killed, 1918
Oil on canvas
51.0 x 61.2 cm

Study for a Mural

British artist Alfred Munnings' painting
depicts a line of soldiers and horses
transporting the wounded. A white-veiled
nurse in a blue uniform leads the procession.

Munnings had attempted to enlist in the
British Expeditionary Force at the outbreak
of the war. But even with the offer of his two
much-loved horses for military service, he
was rejected because he was blind in one eye.
After a stint examining army horses for illness
and parasites, Munnings became an official
artist with the Canadian War Memorials Fund
in 1918. He was assigned to the Canadian
Cavalry Brigade for part of his service and
was later celebrated for his paintings of
horses. Munnings reminisced that "no artist
had been given a better chance to paint in
such unforeseen circumstances."

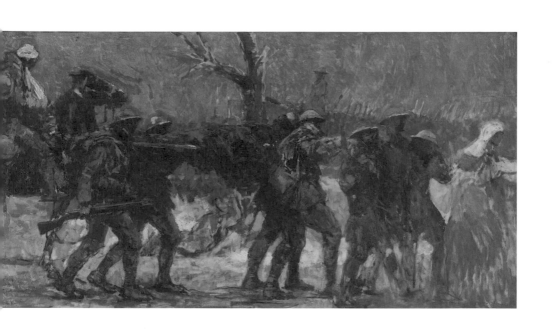

Alfred Munnings (1878–1959)
Study for a Mural, between 1918 and 1919
Oil on paper
75 x 160 cm

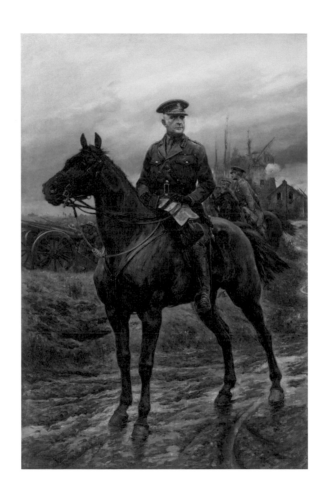

Portrait of Sir Sam Hughes

This painting depicts Sir Sam Hughes, Canada's Minister of Militia and Defence from 1911 to 1916.

The portrait is intended to suggest Hughes' power and prestige. First, at the time it was painted, many would have recognized that British artist R. Caton Woodville was well-known not only for his military paintings but also for his portraits of royalty. Second, mounted on a horse with a gun crew behind him, Hughes is portrayed as a field commander. In reality, this was a position he wanted, but never held. Moreover, Hughes was dismissed from Cabinet in 1916 because of his administrative incompetence and difficult personality.

R. Caton Woodville (1856–1927)
Portrait of Sir Sam Hughes, around 1915
Oil on canvas
183.5 x 122 cm

LANDSCAPES OF WAR

Landscapes dominate Canadian art, so it is no surprise that First World War soldiers and artists painted battlefields.

Both depicted the French and Belgian countryside where Canadians had fought as well as the battles that had raged there. Painted at night, sunset or dawn, their battlefields are illuminated by shellfire, enveloped in smoke, torn up by craters and trenches, and peopled by fighting soldiers.

Artists shared their impressions with those at home through public exhibitions and through personal letters. They exposed Canadians to the conditions soldiers faced, and highlighted their bravery and common purpose on the battlefield. To a large degree, artists omitted the more gruesome realities of war. A hundred years ago, blasted trees and, in some cases, poppy fields symbolized war's human cost for many.

Dawn on the Ouse Trench

This painting shows a group of soldiers, barely visible, clustered in a trench as several flares blaze in the distance.

Official Canadian war artist Maurice Cullen completed this painting after sketching at the front from July to September 1918. He left no record of his intentions for the work but he may have had his four soldier stepsons in mind when he painted the figures. One, John Pilot, was killed in June 1917.

Maurice Cullen (1866–1934)
Dawn on the Ouse Trench, 1918
Oil on canvas
183.5 x 228.5 cm

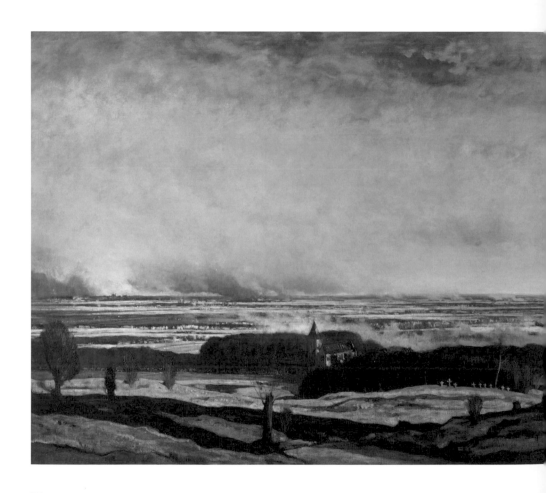

Flanders from Kemmel

In this painting, smoke blankets the plains of Flanders in Belgium, and rises from the distant village. In the foreground, the ravaged trees represent the conflict's unseen human cost.

David Cameron became a Canadian War Memorials Fund artist in 1917 at the age of 52. A renowned Scottish landscape artist, he worked from notes and sketches made at the front. Combining many weeks of observation into one canvas, Cameron made this composite piece as a means of showing the multiple effects of war on the land.

Although Cameron relished his work with the Fund, according to fellow war artist A. Y. Jackson, he was never comfortable with the honourary rank of major bestowed on him. Jackson remembered Cameron saying: "All these fine young Canadians saluting me is not right. I should be saluting them."

David Cameron (1865–1945)
Flanders from Kemmel, 1919
Oil on canvas
197.5 x 336 cm

Untitled

Soldier-artist John Humphries' untitled watercolour depicts an ambulance and a soldier on horseback making their way down a wet road at sunset.

Giving his profession as "cameraman" on his enlistment papers, Humphries joined the Canadian Expeditionary Force in September 1916. By September 1917, he was in France, fighting with the 20th Battalion. In 1919, the war over, Humphries was stationed near the town of Saint-Gérard, Belgium. There, he painted several works directly on the walls of the house in which he was billeted, using colours he had mixed himself from materials he found nearby. After his regiment's departure, he was told the house had become "a shrine to the Canadians" because of the paintings.

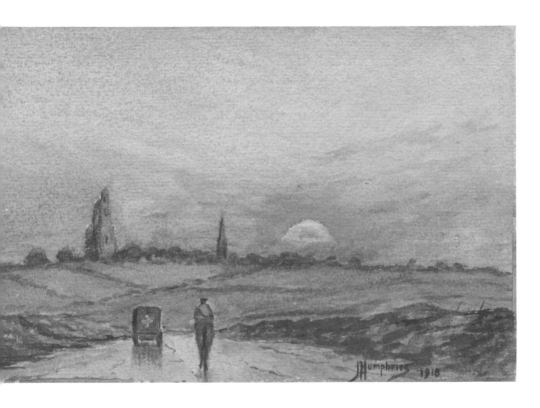

John Humphries (1882–?)
Untitled, 1918
Watercolour on paper
12.5 x 25.7 cm

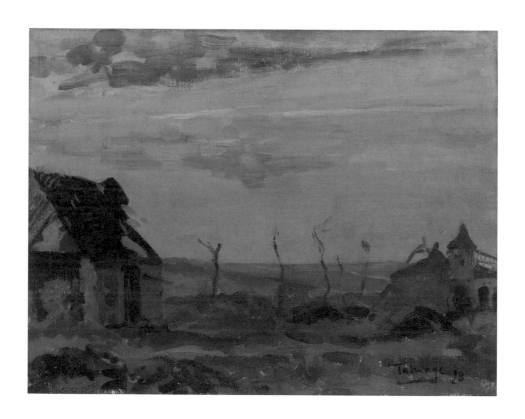

Sunset

This painting shows the setting sun illuminating ruined buildings and shell-blasted trees, somewhere in France.

British artist Algernon Talmage became a war artist with the Canadian War Memorials Fund in 1918. Assigned to the Canadian Army Veterinary Corps, he completed 25 works depicting the care given to wounded and exhausted horses. He also painted the war-torn countryside. Talmage had earned some recognition as both an artist and a teacher before the war. A "calm and gentle" man, he taught many, including Canadian artists Emily Carr and Helen McNicoll.

Algernon Talmage (1871–1939)
Sunset, 1918
Oil on canvas
27.5 x 35.4 cm

Maintaining Tracks by Night, Ypres Sector

Here, men work on railway tracks overnight, while a heavy bombardment goes on behind them. The inscription reads: "With the 10th Canadian Railway Troops, Ypres Sector, Maintaining Track by Night, Whilst Cylinder Gas is brought up, and discharged in No Man's Land, MMs (Military Medals) have been awarded for this Work."

Little is known about soldier-artist T. Leslie. He served with the 10th Battalion, Canadian Railway Troops. When he was not occupied building and maintaining railway lines, Leslie made a series of drawings showing incidents in the history of the Railway Construction Battalion. This sketch may depict events described in the unit's June 1918 war diary entry: "A Company repaired breaks and opened up line...under machine gun fire and gas. The work was very difficult." The maintenance carried out that night kept the railway lines open for a gas attack near Ypres, Belgium.

T. Leslie
Maintaining Tracks by Night, Ypres Sector, undated
Carbon on paper
34.8 x 41.1 cm

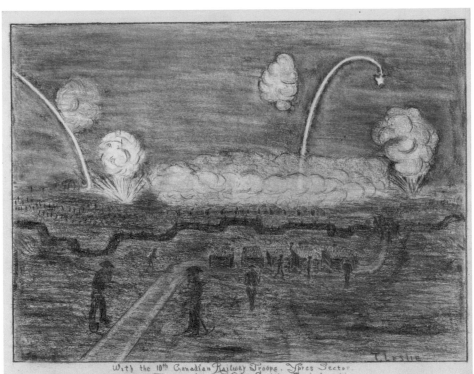

With the 10ᵗʰ Canadian Railway Troops. Ypres Sector.
Maintaining Track by Night. Whilst Cylinder Gas is brought up.
and discharged in no Mans Land Several M.M's have been awarded for this Work.

T. Leslie

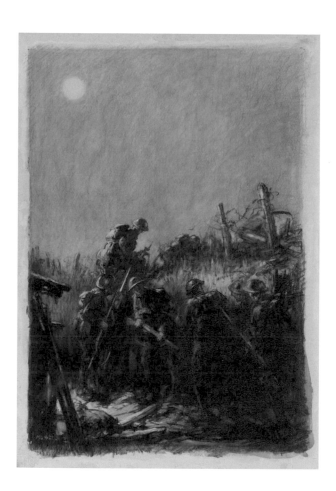

A Night Raid

Under a full moon, the group of soldiers in this drawing leaves their own trench and prepare to raid that of the enemy.

Before the war, artist Harold Mowat drew for the *Ladies' Home Journal* and *The Saturday Evening Post*, both American magazines. He enlisted with the Canadian Expeditionary Force in May 1917 and served briefly as an artillery gunner in France before being assigned to the Canadian War Records Office. In November 1917, Max Aitken, by this time Lord Beaverbrook, selected Mowat to provide drawings for the publication, *Canada in Khaki*.

Harold Mowat (1879–1949)
A Night Raid, between 1917 and 1919
Charcoal and ink wash on cardboard
50.6 x 38.1 cm

Over the Top, Neuville-Vitasse

Belgian artist Alfred Bastien's watercolour study for a larger painting captures the heart-pounding experience of going "over the top." The soldiers scrambling over the trench parapet are Canadians. They are retaking the French village of Neuville-Vitasse from the Germans, in August 1918.

More than a year earlier, on April 8, 1917, Canadian Harold Simpson had put into words the anticipation soldiers felt as they listened for the order to go over the top. Bastien's subjects knew that they were being "called upon to face the most fiendish and effective instruments of destruction that modern science has been able to invent, from the fifteen inch shell to the Mills bomb, from liquid fire to gas."

Alfred Bastien (1873–1955)
Over the Top, Neuville-Vitasse (sketch), 1918
Watercolour on paper
30.8 x 48.5 cm

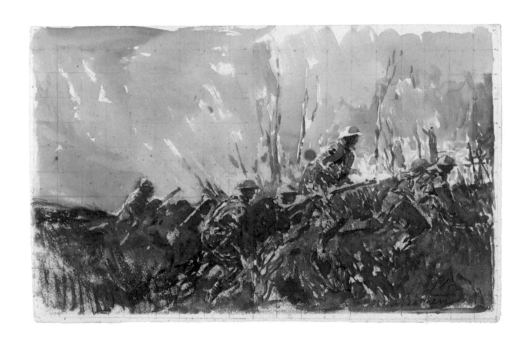

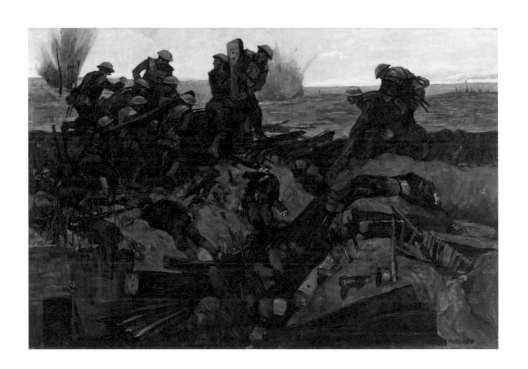

Canadians Repairing a Track under Shell-Fire

This painting captures vividly the dangerous front-line setting in which Canadians laid and repaired railway tracks.

It is the work of British artist and soldier Innes Meo, who had fought at the Somme, in France, in 1916 and, by September of that year, was suffering from shell shock. He wrote in his diary: "What hell it is. Blood-stained articles lie about as memoires [sic] of the slaughter the night before last...I am not strong enough to stand it all." Invalided to England, Meo recovered and returned to the front, only to become a prisoner of war in 1918. In painting this canvas for the Canadian War Memorials Fund after the war, he exercised some creativity. Tracks were not usually located this close to the trenches.

Innes Meo (1886–1967)
Canadians Repairing a Track under Shell-Fire, 1919
Oil on canvas
114.3 x 167.7 cm

Mud Road to Passchendaele

In this painting, men and horses transport ammunition to the guns in the chaos of the horrific Battle of Passchendaele. Also depicted are those who died trying to do the same.

An artist before the war, Douglas Culham served with the 3rd Canadian Divisional Ammunition Column. At Passchendaele, Belgium, in October and November 1917, he and his fellow soldiers used horses to bring ammunition to the guns every night. Life expectancy for the horses was as little as one to two weeks.

The unit's war diary entry for 22 October 1917 supports Culham's depiction: "Wire received from headquarters to commence packing ammunition at once — 150 pack animals delivered 18 pounder ammunition to 10th Brigade Canadian Field Artillery guns... 1 officer, 1 other rank wounded, 1 other rank killed in action — 12 animals killed by shell fire."

Douglas Culham (1886–?)
Mud Road to Passchendaele, around 1917
Oil on canvas
82.2 x 107.5 cm

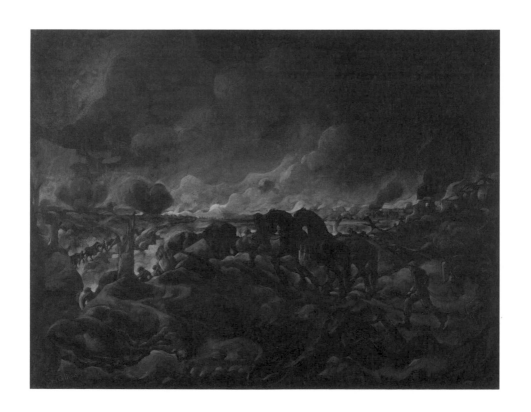

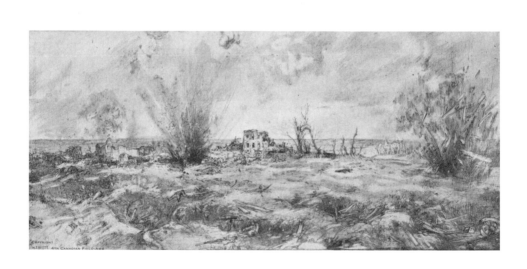

COPYRIGHT
H.E. BUTT 4TH CANADIAN FIELD-AMB.

80

After Courcelette

Set against a barren landscape, a heavily damaged building shows the effects of an ongoing bombardment. The inscription on the print reads: "Taken by the Canadians on September 16th, 1916."

A grocer by trade, soldier-artist Harold Brett had also studied art. He enlisted in the Canadian Expeditionary Force in November 1914 and served with the 4th Canadian Field Ambulance. His military career was somewhat checkered.

Although he forfeited several days' pay for having been absent without leave, he also received the Military Medal, a decoration awarded for acts of bravery. In a letter to his parents, Brett explained what he had done: "It was for staying with a badly wounded man...and sticking by him in a shell hole... during a heavy counter-attack...My nerves felt like steel wires, but I volunteered to stay, and told the rest of my squad to 'beat it'."

Harold Brett (1891–1974)
After Courcelette, around 1916
Commercial print on paper
26.5 x 45.6 cm

The Somme Bombardment in Full Swing

Here, we see part of the June 1916 bombardment that opened the bloody five-month Battle of the Somme. Canadian soldier-artist Thurston Topham's annotations give the work a sense of immediacy: "white puffs are shrapnell [sic]"; "high explosive shells bursting are percussion [cap shells]"; and "gas drifting in the hollow."

Topham had been in France for only two weeks when he completed this watercolour of the bombardment of the village of Fricourt, France, on 29 June 1916. More than two years later, in the November 1918 edition of the American *Scribner's Magazine*, Topham wrote that it had been "one of the most strongly organized defenses of the Germans at the opening of the Somme offensive, and was the centre of bitter hand-to-hand fighting, notwithstanding its continuous bombardment for four days and nights by guns of all calibers."

Thurston Topham (1888–1966)
The Somme Bombardment in Full Swing, 1916
Watercolour on paper
12 x 16.5 cm

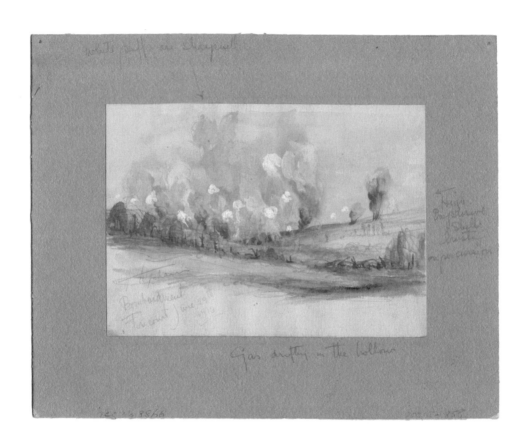

white puff. our shrapnel

High
Explosive
Shells
burst
on previous line

Bombardment
The out June 1918

Gas drifting in the hollow

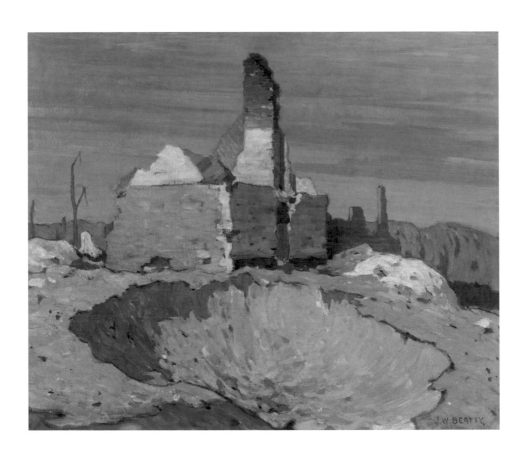

A Shell Hole

Painted by official Canadian war artist William Beatty, this shell hole looks as though it was dug by a giant, jagged-edged spoon. In reality, a massive explosion had gouged the earth.

The sun-drenched scene belies the danger Beatty experienced while drawing at the front. Describing his attempts to work while bullets rained close by, he wrote: "...it is not conducive to steady draughtsmanship to work under these conditions." The tranquility of Beatty's painting also fails to reveal his own profound emotional response to the devastation he saw at the Western Front. Deeply disturbed by the destructive power of modern warfare, Beatty, a veteran of the 1885 Northwest Resistance, stopped wearing his campaign medal when he returned to Canada.

William Beatty (1869–1941)
A Shell Hole, between 1917 and 1919
Oil on canvas
64 x 76.5 cm

Mine Crater, Vimy Ridge

In this print, Canadian Gyrth Russell depicts
a crater at Vimy Ridge.

Russell became an official war artist in 1918.
He reminisced: "I was taken to France where
I joined the Canadian headquarters (at
Aubigny). I was allotted a car and a driver
who was instructed to drive me anywhere in
the area occupied by Canadians." He was told
his choice of subject would be approved if
"it had anything whatever to do with the war,"
and craters certainly did. Of strategic value,
they were often made on purpose, using
explosives, and then fortified with barbed
wired, as seen in this print.

Gyrth Russell (1892–1970)
Mine Crater, Vimy Ridge, between 1918 and 1919
Drypoint on paper
23.2 x 29.2 cm

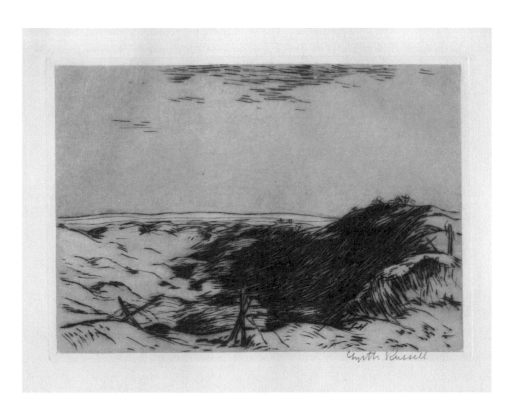

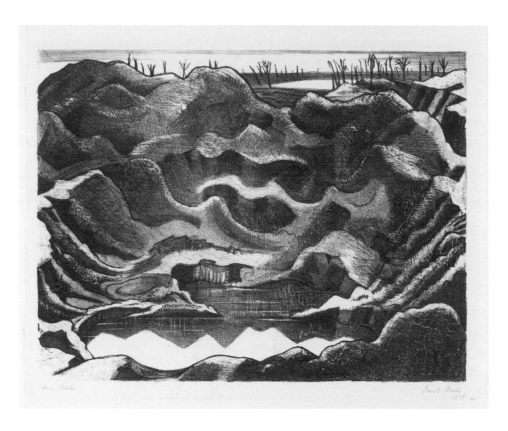

Paul Nash
1918

88

Mine Crater, Hill 60

Here, we see one of the craters blown into Hill 60, near Ypres, Belgium, in April 1915, when Allied Forces detonated a massive quantity of explosives.

British artist Paul Nash served in France as an officer with the Hampshire Regiment. After breaking a rib, he returned to England in the spring of 1917 to recover. Soon after this, most of his fellow officers died in an attack at Hill 60. An official war artist as of October 1917, working for both the British and the Canadian schemes, Nash was enraged by the seemingly endless war and its toll on human beings. He wrote: "I am no longer an artist interested and curious, I am a messenger who will bring back word from the men who are fighting to those who want the war to go on forever. Feeble, inarticulate, will be my message, but it will have a bitter truth, and may it burn their lousy souls."

Paul Nash (1889–1946)
Mine Crater, Hill 60, 1918
Lithograph on paper
50.8 x 63.4 cm

Scottish Canadians in the Dust, Vimy

In this watercolour, nine helmeted Canadian
soldiers from a Scottish regiment march down
a dusty road, each carrying his kit and a rifle.
On either side of them, poppies bloom.

Belgian artist Alfred Bastien fought with his
country's military during the First World War
until a 1917 chance encounter with Canada's
Lord Beaverbrook, who owned an example
of his work. Beaverbrook arranged to have
Bastien seconded from the Belgian Army to
the Canadian War Memorials Fund. While
he spent some time assigned to the Royal 22e
Régiment (also known as the Royal 22nd
Regiment), Bastien also painted Canadians
serving in other units.

Alfred Bastien (1873–1955)
Scottish Canadians in the Dust, Vimy, 1918
Watercolour on paper
31.5 x 47.6 cm

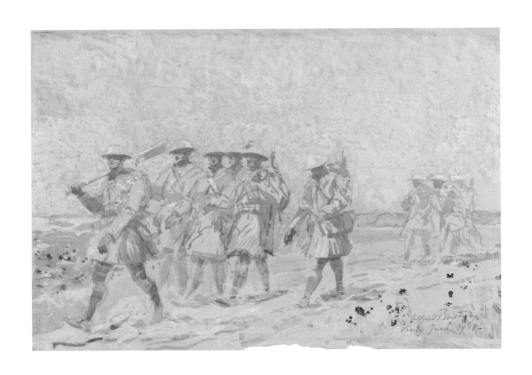

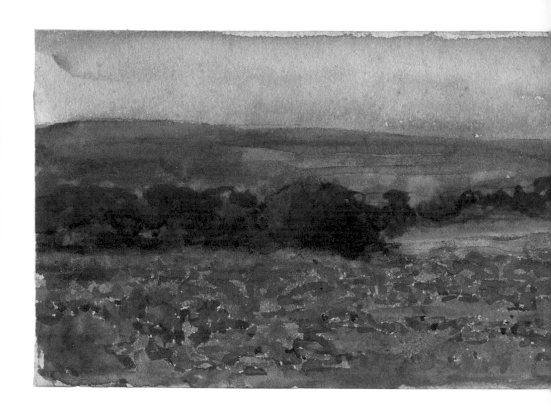

A Poppy Field, France

This watercolour by Canadian Vivian Cummings is a surprisingly rare depiction of a poppy field and reminds us that dirt, mud and sludge were not the only landscapes of the Western Front. It may have been inspired by John McCrae's popular 1915 poem, *In Flanders Fields*, which made the poppy a well-known symbol of remembrance for the war dead.

An architect before the war, Cummings fought in France from 1916 to early 1918. He painted this work at some point between August and November 1918, while hospitalized with trench fever. This disease caused fever, headaches, sore muscles and skin lesions in its sufferers. Infectious and transmitted by lice, it became a severe problem for troops during the war.

Vivian Cummings (1875–?)
A Poppy Field, France, around 1918
Watercolour on paper
8 x 17.1 cm

The Cemetery, Pas de Calais

This painting shows a cemetery located just
north of Étaples, France. It may appear small,
but there are nearly 11,000 dead buried there,
including more than 1,000 Canadians.

British landscape painter Herbert Hughes-
Stanton arrived in France in November 1918.
He was one of very few artists who depicted
the newly created military cemeteries.
In Hughes-Stanton's work, all the grave
markers are wooden crosses. Beginning in
1920, the Imperial War Graves Commission,
now the Commonwealth War Graves
Commission, replaced them with
white headstones.

Herbert Hughes-Stanton (1870–1937)
The Cemetery, Pas de Calais, 1919
Oil on canvas
152.5 x 213 cm

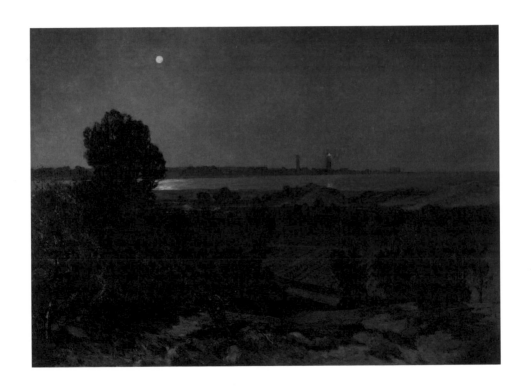

RUINS OF WAR

War artists, officially commissioned professionals and soldiers alike, depicted war's impact on homes, villages, towns and churches. Some also painted the abandoned French châteaux in which they were billeted.

Artists saw a tragic beauty in the devastation they encountered. For many, ruined buildings symbolized war's ravages on human beings and represented the dead they rarely painted.

One hundred years later, the reluctance of artists to depict human carnage may seem overly cautious, but most had no desire to shock. Their respect for family, friends and dead comrades conditioned their work. Depicting destroyed buildings was a gentler means of conveying to private and public audiences the enormous human cost of war.

Untitled

Canadian soldier-artist Poul Jensen painted this ruined house. Behind it is another destroyed building and a downed electrical pole.

Danish-born Jensen enlisted with the Canadian Expeditionary Force in December 1914. He suffered a shrapnel wound to his scalp in 1915 and later experienced serious migraines. While hospitalized in 1916 for pleurisy (inflammation of the lining surrounding the lungs), Jensen, an amateur artist, painted this scene. Much of the French and Belgian countryside had served as a battlefield since the war began in August 1914, making homes in this state a common sight for soldiers on active service.

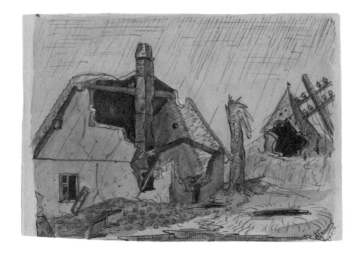

Poul Jensen (1892–?)
Untitled, 1916
Ink and watercolour on paper
7.8 x 11 cm

Untitled

This watercolour depicts a demolished town, "somewhere in France."

Soldier-artist Henry Howchin enlisted in the Canadian Expeditionary Force in March 1916. While fighting in France in 1918, he was forced to hide from the Germans for 10 days in a bombed-out building. According to family legend, this painting shows the view from his hideout. Howchin returned to Canada after the war and taught art at the Danforth Technical School in Toronto, Ontario.

Henry Howchin (1888–?)
Untitled, 1918
Watercolour on art board
38.5 x 55 cm

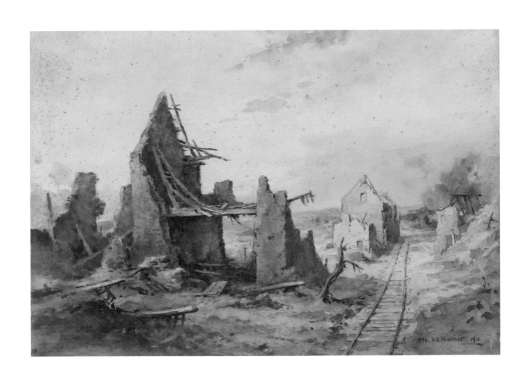

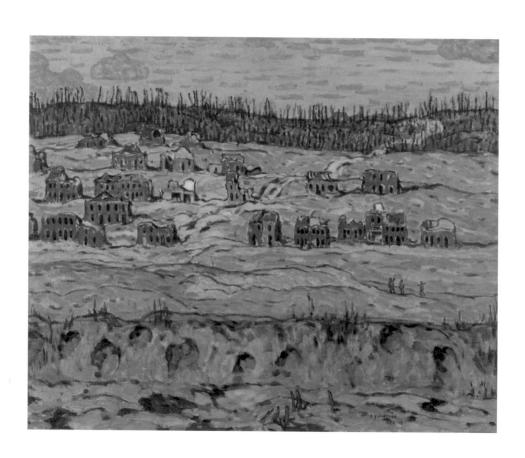

Riaumont

Future Group of Seven artist A. Y. Jackson sketched the ruined French village of Riaumont in March 1918, as the fighting raged around him. Jackson "made little more than pencil notes, finding it hard to manage a sketch box while shells were dropping here and there." He produced this painting later.

Jackson did not enter the conflict as a war artist. He enlisted in the Canadian Expeditionary Force in June 1915 and was wounded at Maple Copse, Belgium, a year later. Jackson learned of the new Canadian War Memorials Fund while recuperating. After a successful interview, Jackson became one of the first Canadian artists to work for the Fund. He found that, at times, his term as an infantryman helped him as an artist. While at Riaumont in 1918, soldiers who at first were distant, were glad to help him once they learned he too had been a fighting soldier.

A. Y. Jackson (1882–1974)
Riaumont, 1918
Oil on canvas
63.3 x 76.3 cm

First Glimpse of Ypres

Here, a plume of smoke, perhaps from
an artillery shell, rises above the distant,
shattered city of Ypres, Belgium. Three
Canadian soldiers are in the foreground
of the painting.

English-born artist Cyril Barraud immigrated
to Canada in 1913 but returned to England
in 1915 as an officer with the Canadian
Expeditionary Force's 43rd Battalion. He
became an official war artist in November
1917 but even before that, during his time as
a fighting soldier, a pen and sketchbook were
as much a part of his kit as a rifle and bullets.
Today, the drawings and prints Barraud made
at this time are, in some cases, the only
remaining depictions of buildings destroyed
during the war.

Cyril Barraud (1877–1965)
First Glimpse of Ypres, between 1917 and 1919
Watercolour on art board
36.4 x 53.1 cm

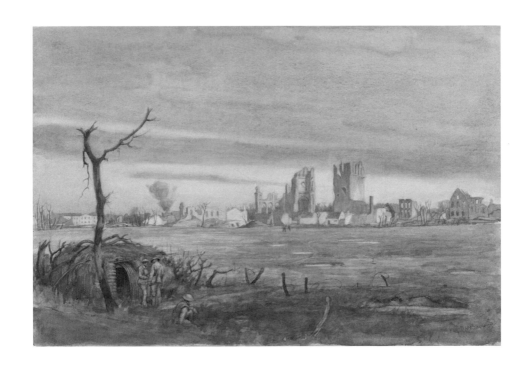

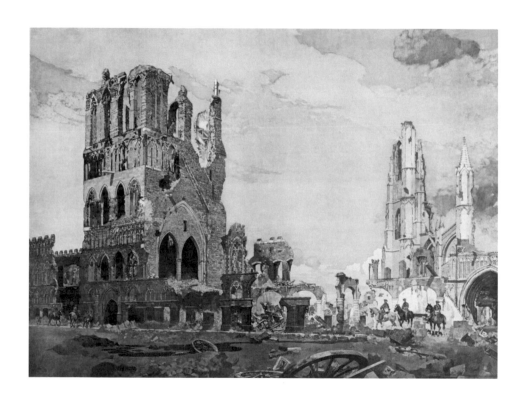

The Cloth Hall, Ypres

This print depicts the Cloth Hall in Ypres, Belgium. Constructed in the 13th century, it was reduced to rubble, along with the rest of the city, by continual shelling and artillery fire between 1914 and 1918. Despite repeated attacks, Ypres never fell to the Germans and the remnants of the Cloth Hall became an iconic symbol of Belgian and Allied resistance and resilience.

In 1917, the Canadian War Memorials Fund commissioned James Kerr-Lawson to paint two large paintings, one each of the devastated cities of Ypres, in Belgium, and Arras, in France. The Fund sold prints like this one of Kerr-Lawson's *The Cloth Hall, Ypres* to finance its scheme.

James Kerr-Lawson (1862–1939)
The Cloth Hall, Ypres, around 1918
Commercial print on paper
49 x 61 cm

Arras Ruins, 1917

This drawing by Canadian soldier-artist André Biéler shows the ravaged city of Arras, France. Taking advantage of its chalky soil to dig protective bunkers and tunnels, the Allies turned Arras into a stronghold during the war. This made it a target of German shelling.

Biéler enlisted with the Princess Patricia's Canadian Light Infantry in March 1915. Assigned to the Arras sector, he fought and was wounded at Vimy Ridge in April 1917. Gassed at Passchendaele, in Belgium, later that year, Biéler's asthma worsened and he was transferred to the Canadian Corps Topographic Section as a technical illustrator. Here, Biéler realized that, after the war, he wanted to be an artist. He accomplished his goal, becoming a painter and a professor of art at Queen's University in Kingston, Ontario.

André Biéler (1896–1988)
Arras Ruins, 1917, 1917
Ink on paper
17.1 x 21.7 cm

ARRAS

108

Section of Arras Cathedral

In this sketch, Major Herbert Alley depicts a section of the ruined cathedral at Arras, France, which was devastated by shelling in April 1917. Built in 1833, it had replaced a medieval structure destroyed by warfare during the French Revolution (1787–1799).

A law student when he enlisted in September 1914, Alley fought at the 1915 Second Battle of Ypres, in Belgium, and at the 1916 Battle of Courcelette, in France. His right arm severely injured at Courcelette, Alley completed his service with the War Office. He re-enlisted in the Second World War and became the commanding officer of the Veterans Guard of Canada. Among other tasks, this force, comprised largely of First World War veterans, guarded prisoner of war camps in Canada.

Herbert Alley (1892–1936)
Section of Arras Cathedral, undated
Graphite on paper
18.4 x 12.6 cm

Ruins of the Church of Ablain-Saint-Nazaire and Vimy Ridge

Here, soldier-artist Frederick Bush depicts the ruined church at Ablain-Saint-Nazaire, France, a rest spot for Canadian soldiers.

Bush enlisted in the Canadian Expeditionary Force in November 1914. An architect before the war, in November 1917 he was transferred to the Canadian Corps Topographic Section. This unit undertook surveys, created maps and drew the French and Belgian battlefield terrain, among other tasks. In July 1918, Bush's artistic abilities were again put to use, this time as a camouflage officer. His work included designing and painting camouflage patterns on artillery, building observation trees and developing methods to hide key military positions from aerial detection. This print, showing the sloping terrain surrounding the ruined church, demonstrates Bush's skill as both architect and artist.

Frederick Bush (1887–1986)
Ruins of the Church of Ablain-Saint-Nazaire and Vimy Ridge, between 1917 and 1918
Lithograph on paper
28.8 x 39.4 cm

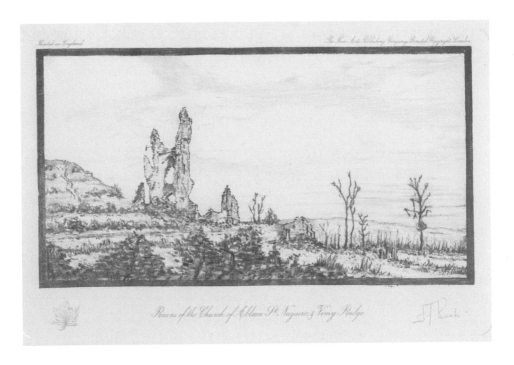

Ruins of the Church of Ablain St. Nazaire, & Vimy Ridge.

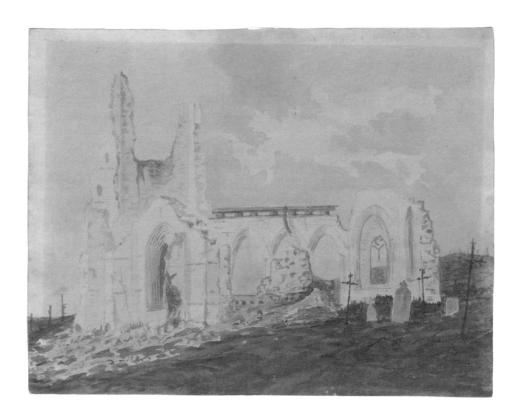

Church of Ablain-Saint-Nazaire

An accountant before the war, soldier-artist Henry Crumplin painted this watercolour of the destroyed church at Ablain-Saint-Nazaire, France. Not visible in Crumplin's painting, but still in place today, is the graffiti that soldiers left on the walls. Long dead now, the men live on through their inscriptions: "A. E. John Toronto Canada," "Dempsey CEF" and "R. Greer."

Crumplin enlisted in the Canadian Expeditionary Force in December 1916. He arrived in England in March 1918 and went to France in September of that year with the Royal Canadian Engineers. Although not wounded, Crumplin did not escape service in the Canadian Expeditionary Force completely unscathed. He contracted Spanish flu in December 1918. While Crumplin survived, the flu pandemic killed millions worldwide.

Henry Crumplin (1885–1953)
Church of Ablain-Saint-Nazaire, between 1915 and 1919
Watercolour and chalk on paper
19 x 24 cm

White Chateau, Liévin

The destroyed building and the injured soldier
in this painting both highlight the devastating
cost of war.

Canadian Gyrth Russell became an official
war artist in early 1918. Reminiscing about
what he called the "world's first attempted
suicide," he later wrote: "I hated the war.
It was contrary to everything I valued and
believed in. I don't think it was just the fear of
death...but the thought of being buried alive in
a filthy trench and my body serving to fertilize
a French peasant's crop of root vegetables!"

Gyrth Russell (1892–1970)
White Chateau, Liévin, 1918
Oil on canvas
86.4 x 113.1 cm

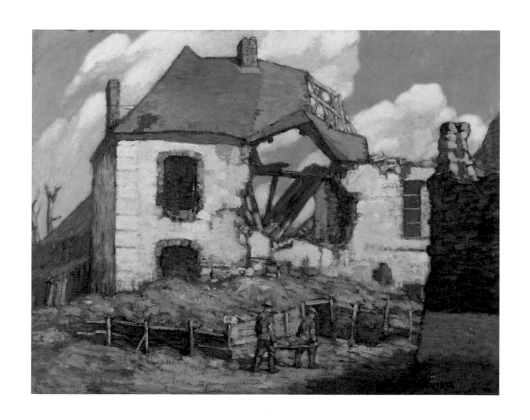

Château de Olhain

This print shows Château d'Olhain, a
Canadian billet in northern France, as the
picture of tranquility.

But soldier-artist Frederick Clemesha's
wartime experiences were far from tranquil.
He was a member of the "Suicide Battalion,"
the 46th Battalion, which had a 91.5 percent
casualty rate. Clemesha was more fortunate
than many of his comrades. Although he
suffered a gunshot wound to the cheek, it was
a light injury, and he was away from his unit
receiving medical treatment for just 13 days.

An architect by training, after the war
Clemesha designed the St. Julien memorial,
which commemorates Canada's participation
in the April 1915 Second Battle of Ypres,
in Belgium.

Frederick Clemesha (1876–1958)
Château de Olhain, 1920
Lithograph on paper
16.7 x 25.2 cm

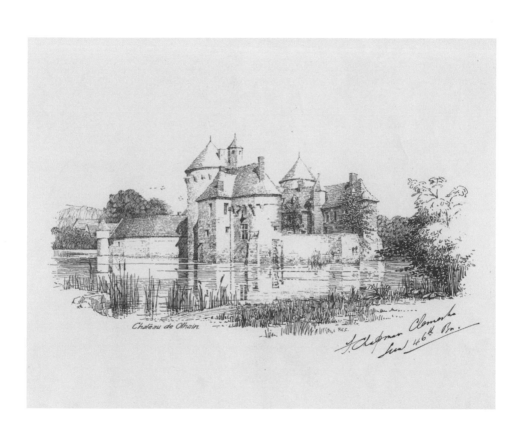

Château de Olhain.

F. Chapman Clarke
Lieut 46th Bn.

PHOTO CREDITS

p.92	20110004-024
p.107	20060027-001
p.111	20110136-002

Steven Darby:
p.7 IMG2012-0213-0005-Dm

Beaverbrook Collection of War Art:

p.11	19710261-0148
p.13	19710261-0811
p.14	19710261-0503
p.17	19710261-0732
p.19	19730157-018
p.20	19710261-0686
p.22	19860118-004
p.23	19770475-001
p.25	19730318-001
p.26	19700046-009
p.27	19920163-001
p.28	20030122-008
p.31	19710261-0834
p.32	19990069-002
p.35	19710261-0508
p.36	19710261-0771
p.39	19880266-004
p.40	19710261-0152
p.43	19710261-0343
p.44	19710261-0661
p.47	19880007-002
p.48	19850327-024
p.51	19880154-001
p.55	19710261-0210
p.56	19710261-0094
p.59	19710261-0482
p.60	19900155-001
p.63	19710261-0130
p.64	19710261-0117
p.67	20010175-001
p.68	19710261-0712
p.71	19810161-020
p.72	19710261-0431
p.75	19710261-0057
p.76	19710261-0412
p.79	19890222-001
p.80	19640037-047
p.83	19710261-0725
p.84	19710261-0104
p.87	19710261-0636
p.88	19710261-0515
p.91	19710261-0067
p.95	19710261-0684
p.97	19900319-008
p.99	20010196-002
p.100	19710261-0173
p.103	19710261-0021
p.104	20010022-005
p.108	19830323-014
p.112	19840499-001
p.115	19710261-0622
p.117	19910216-340

Transfer from the Canadian War Memorials, 1921
p.52 8438